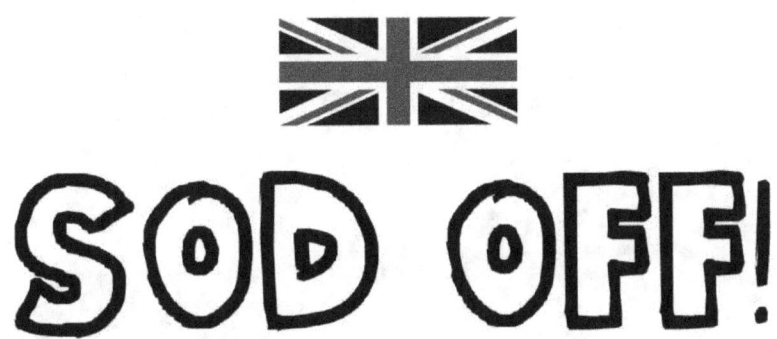

# SOD OFF!

## SWEAR LIKE A BRIT

### Adult Coloring Book

by InnerAct Studio

Copyright © 2019  InnerAct Studio, LLC

All Rights Reserved. No part of this No part of this book may be reproduced, distributed, or transmitted in any form or by any means, including photocopying or other mechanical methods without the prior written permission of the author.

# DEDICATION

This book is dedicated to the Milligan family- the biggest bunch of twunts I've ever had the pleasure of meeting. Thank you for being so lovingly welcoming.

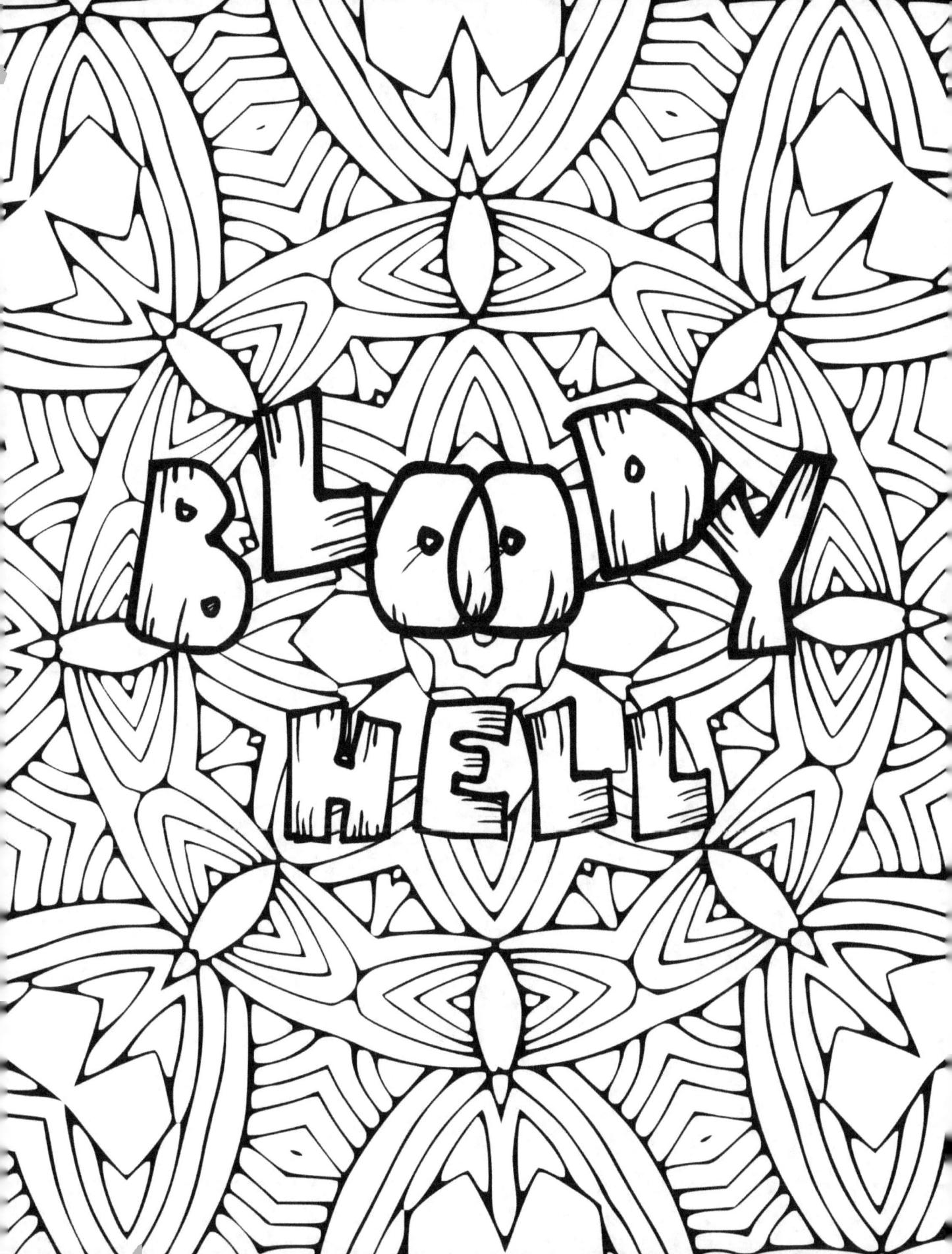

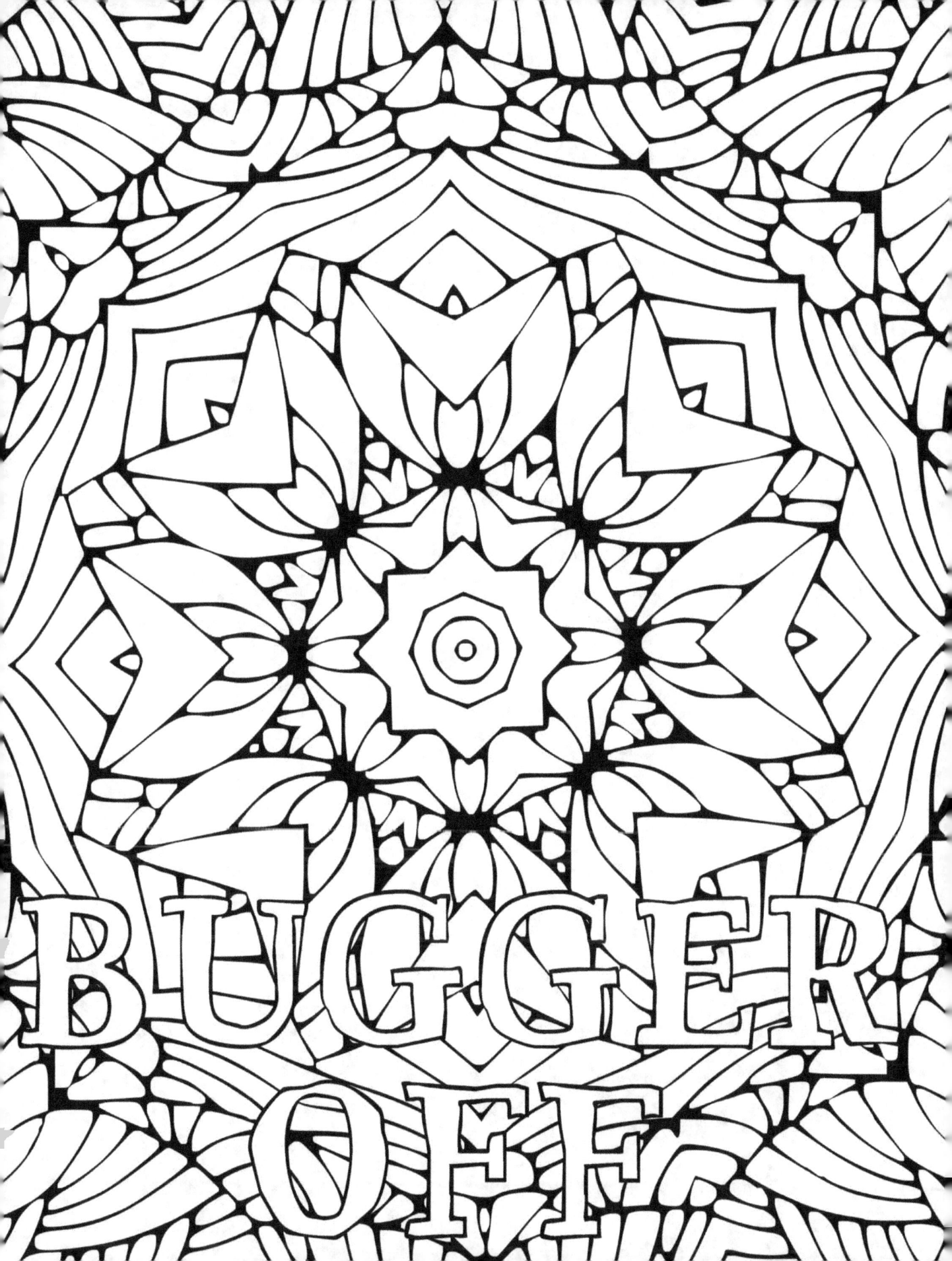

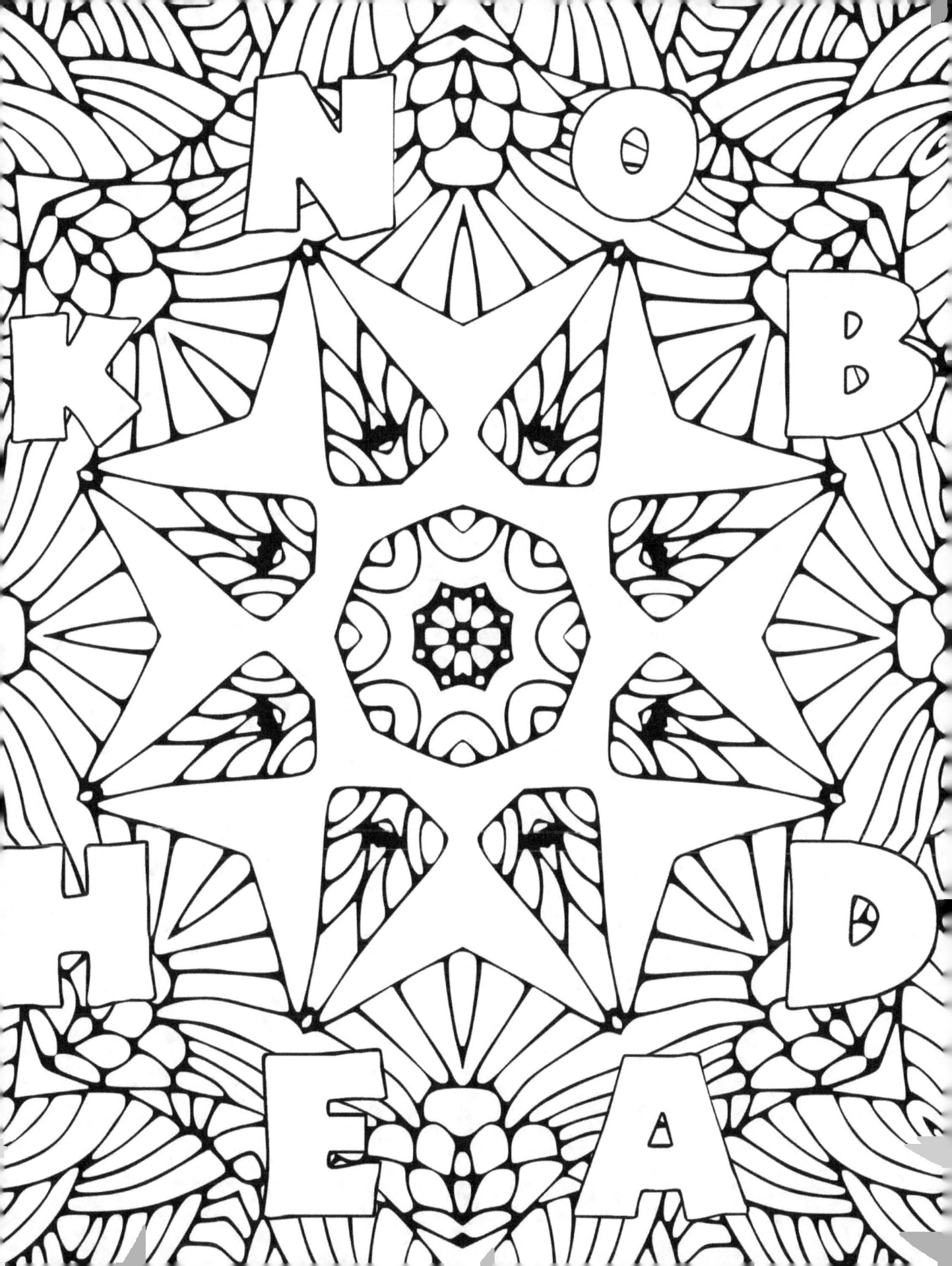

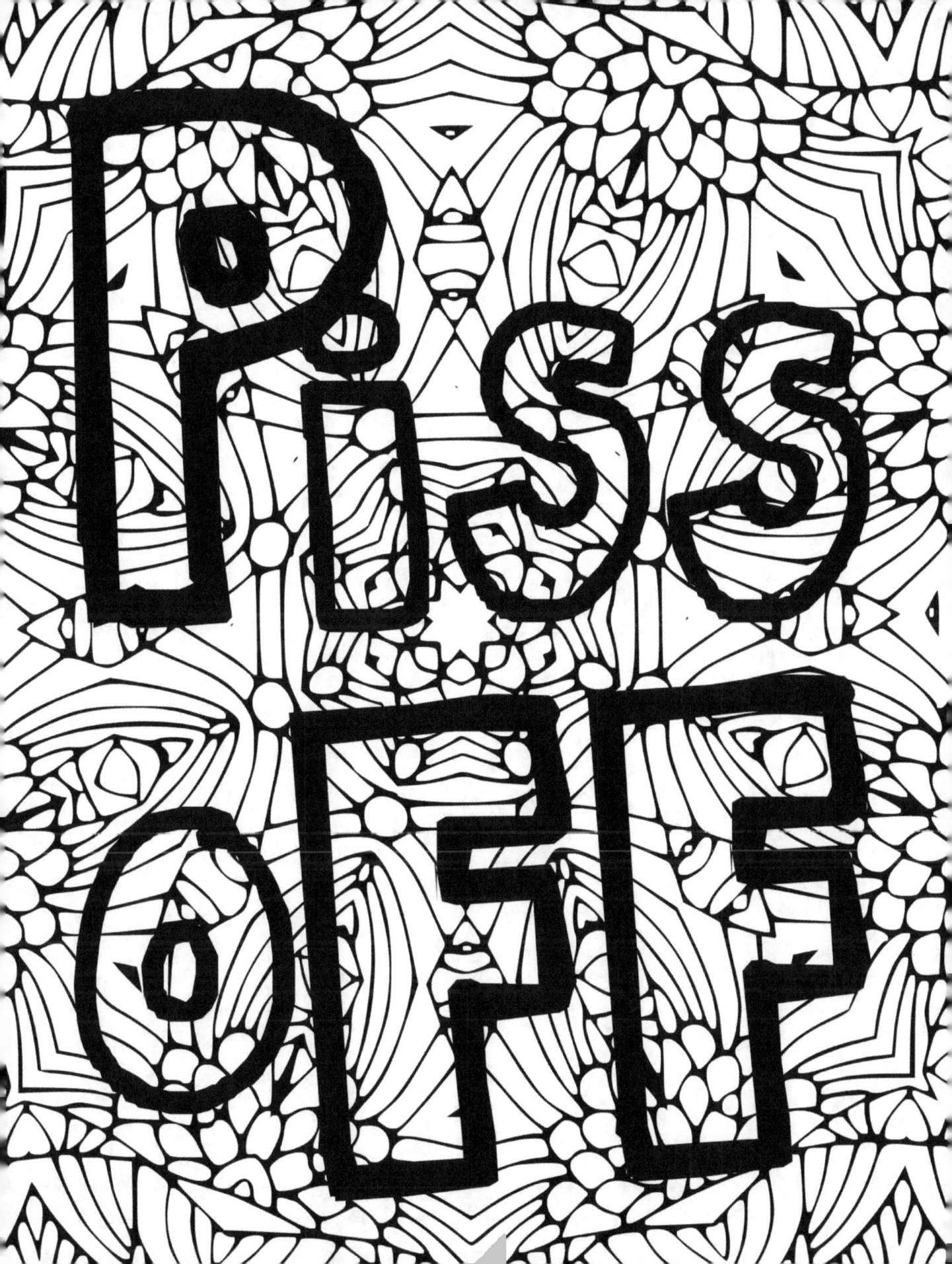

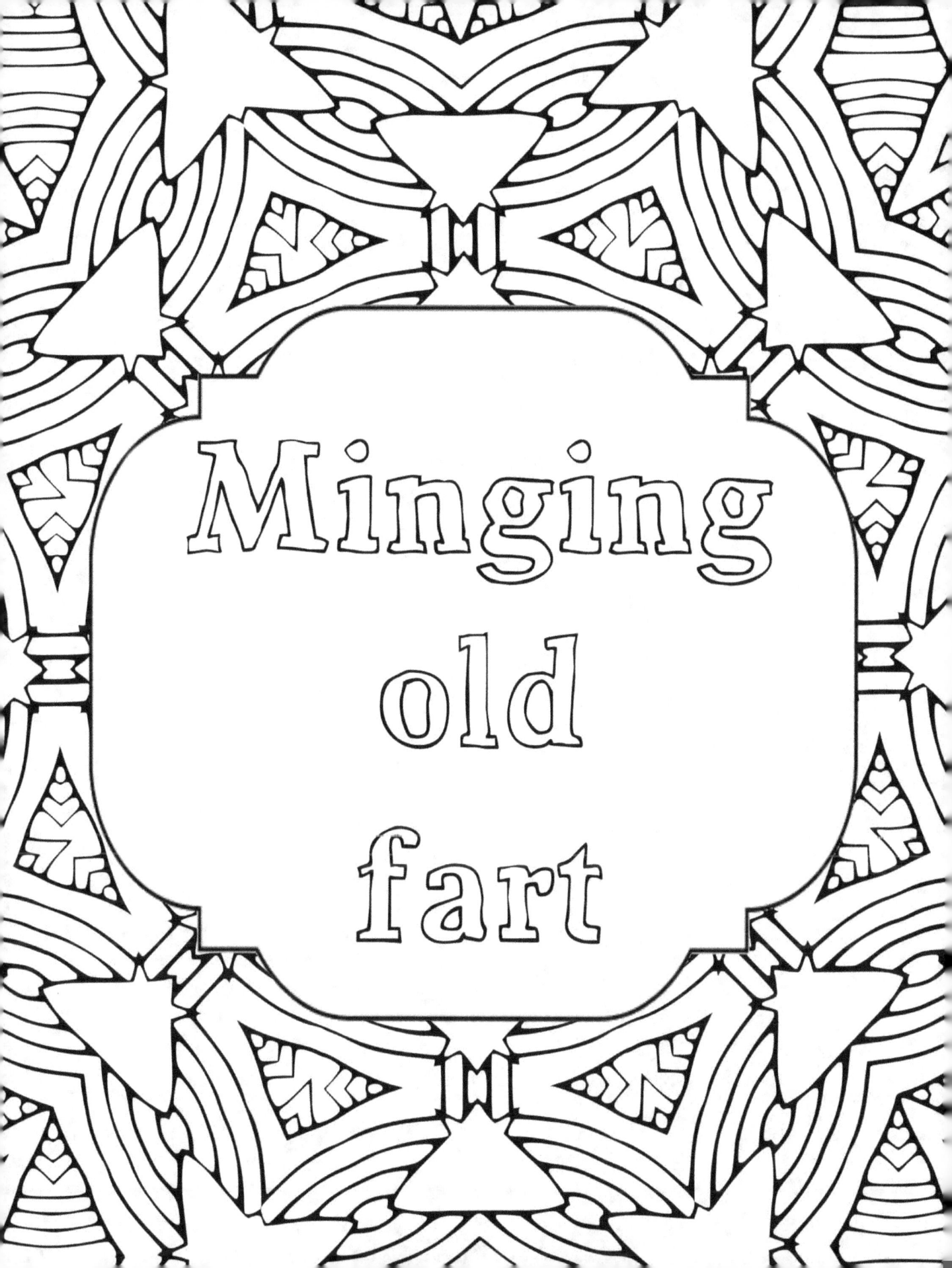

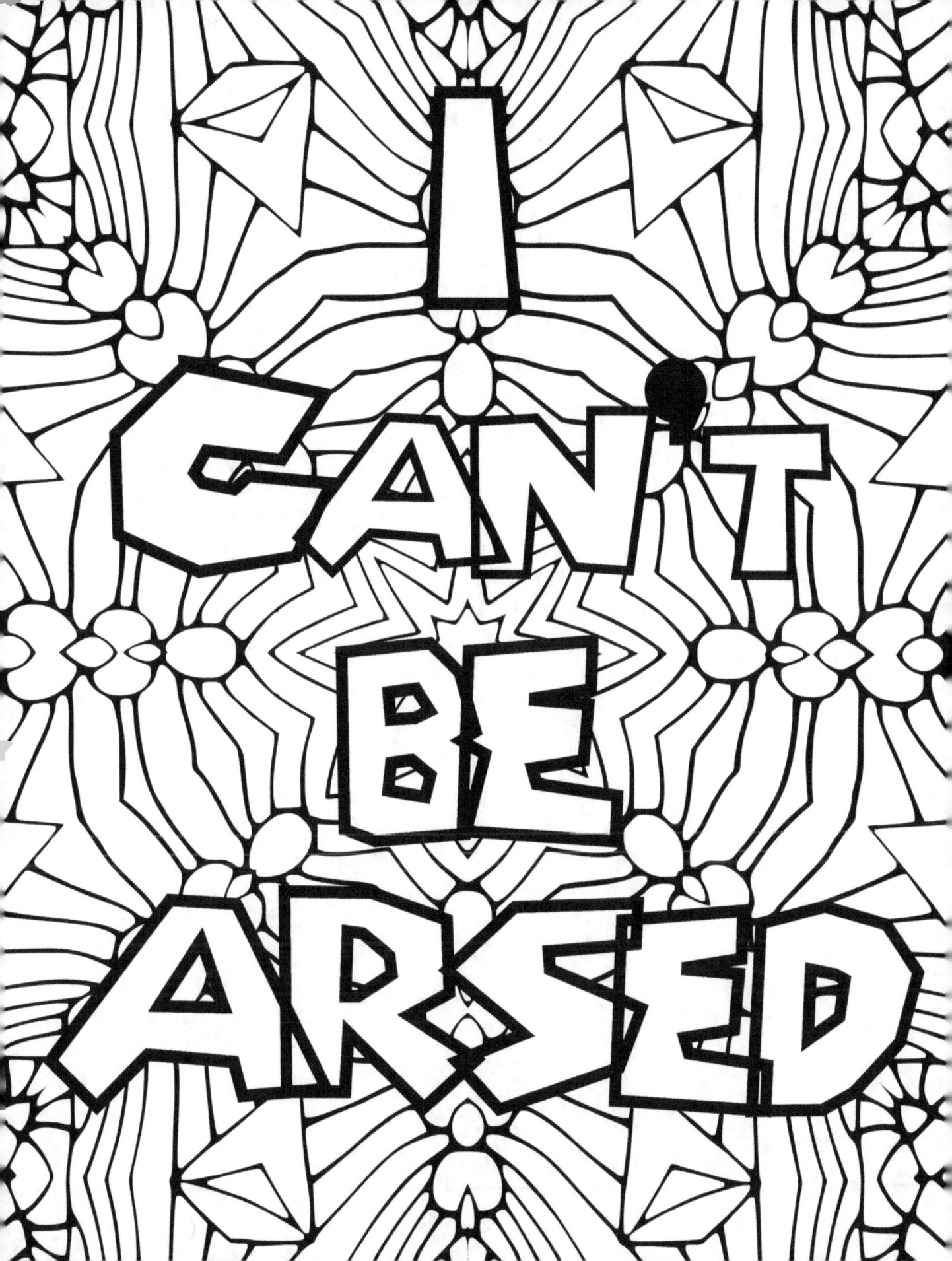

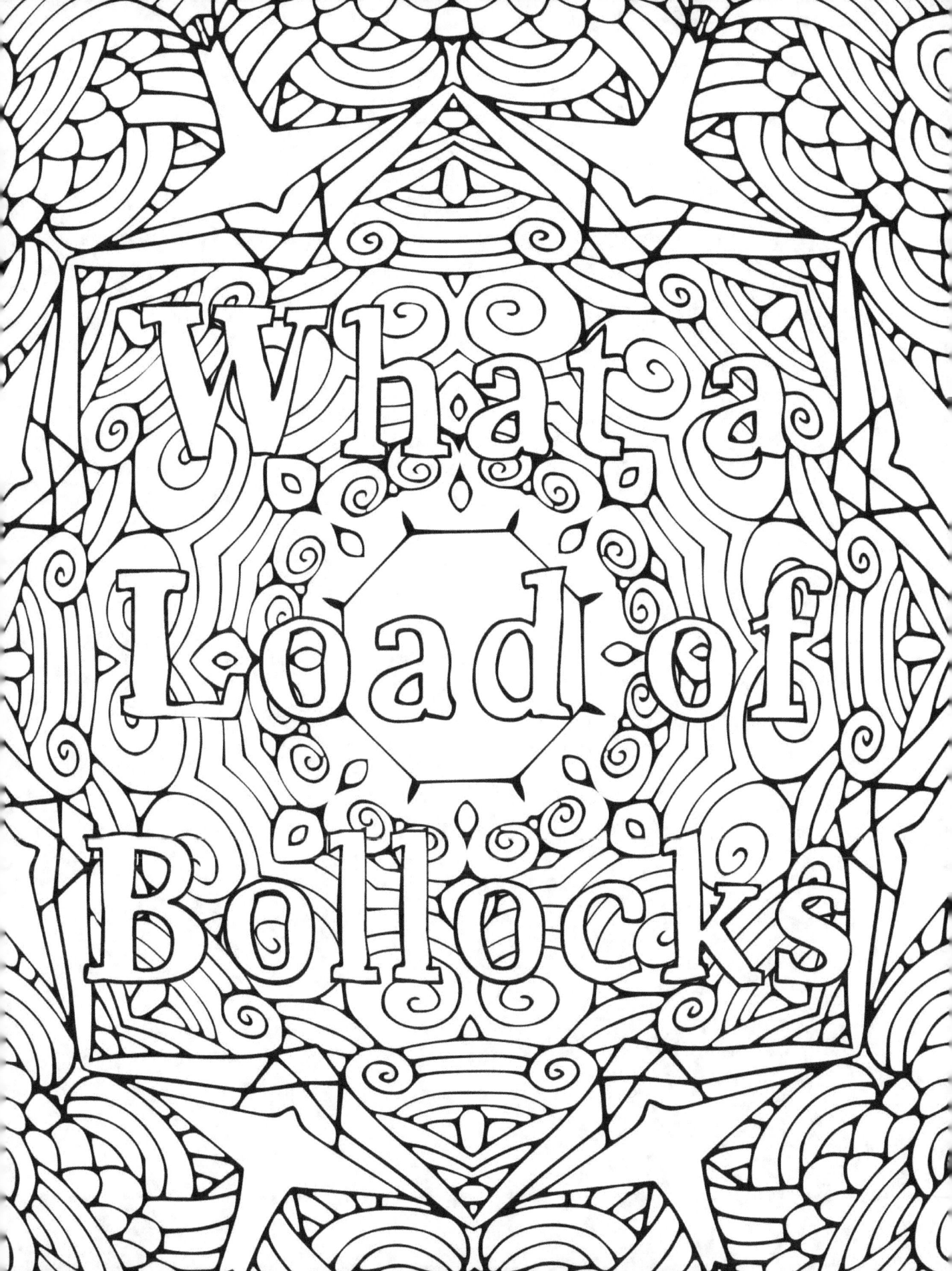

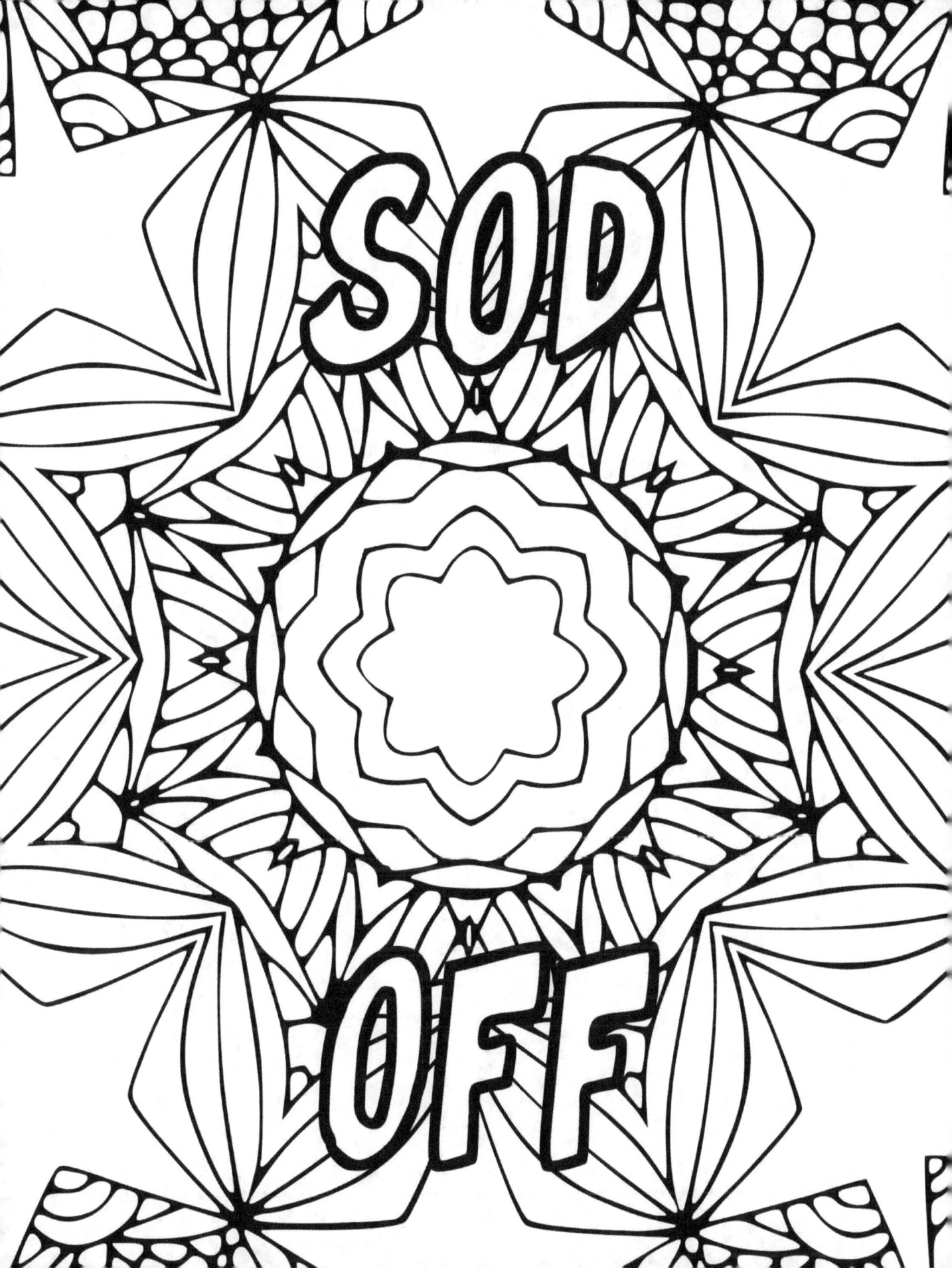

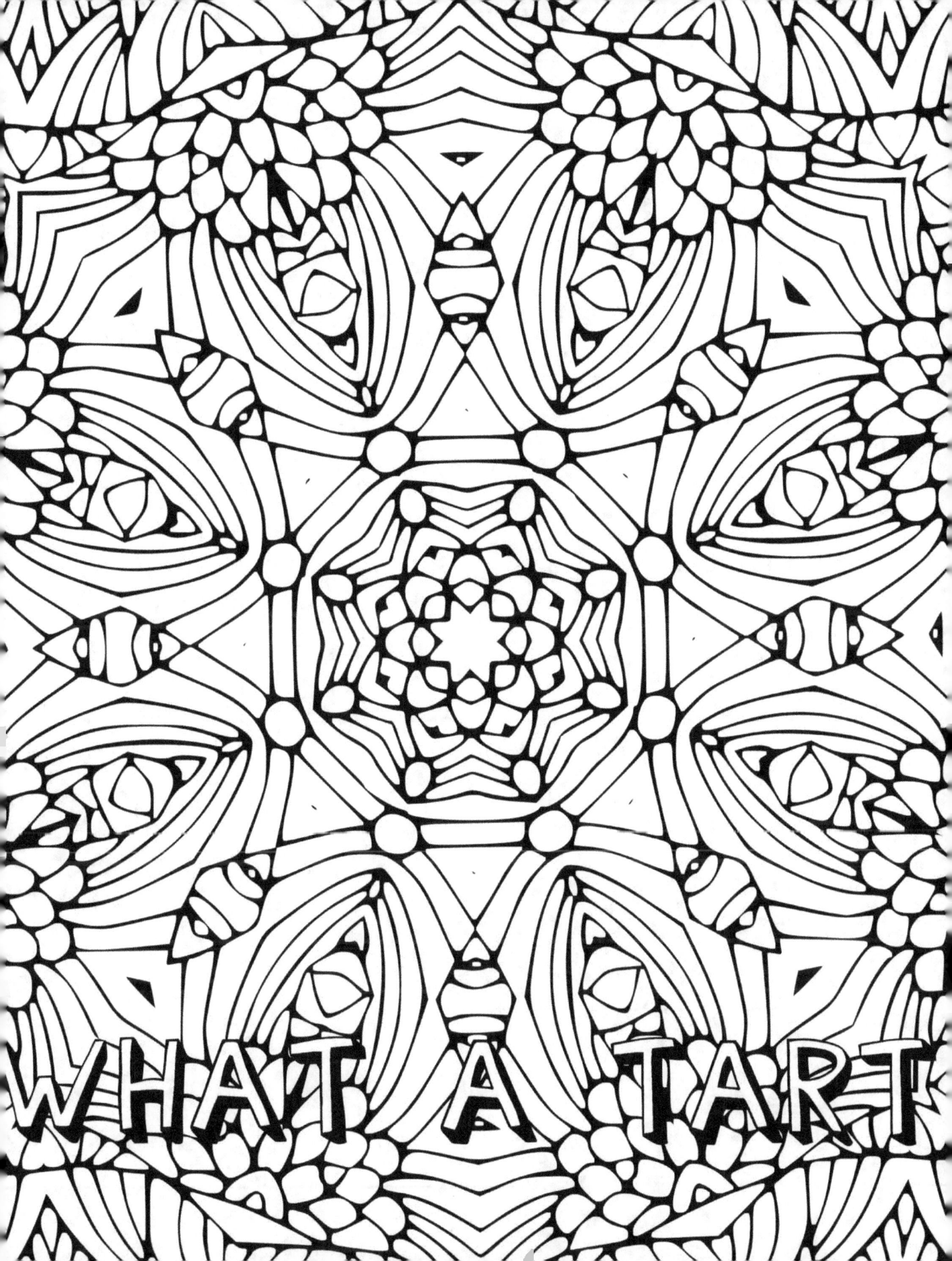

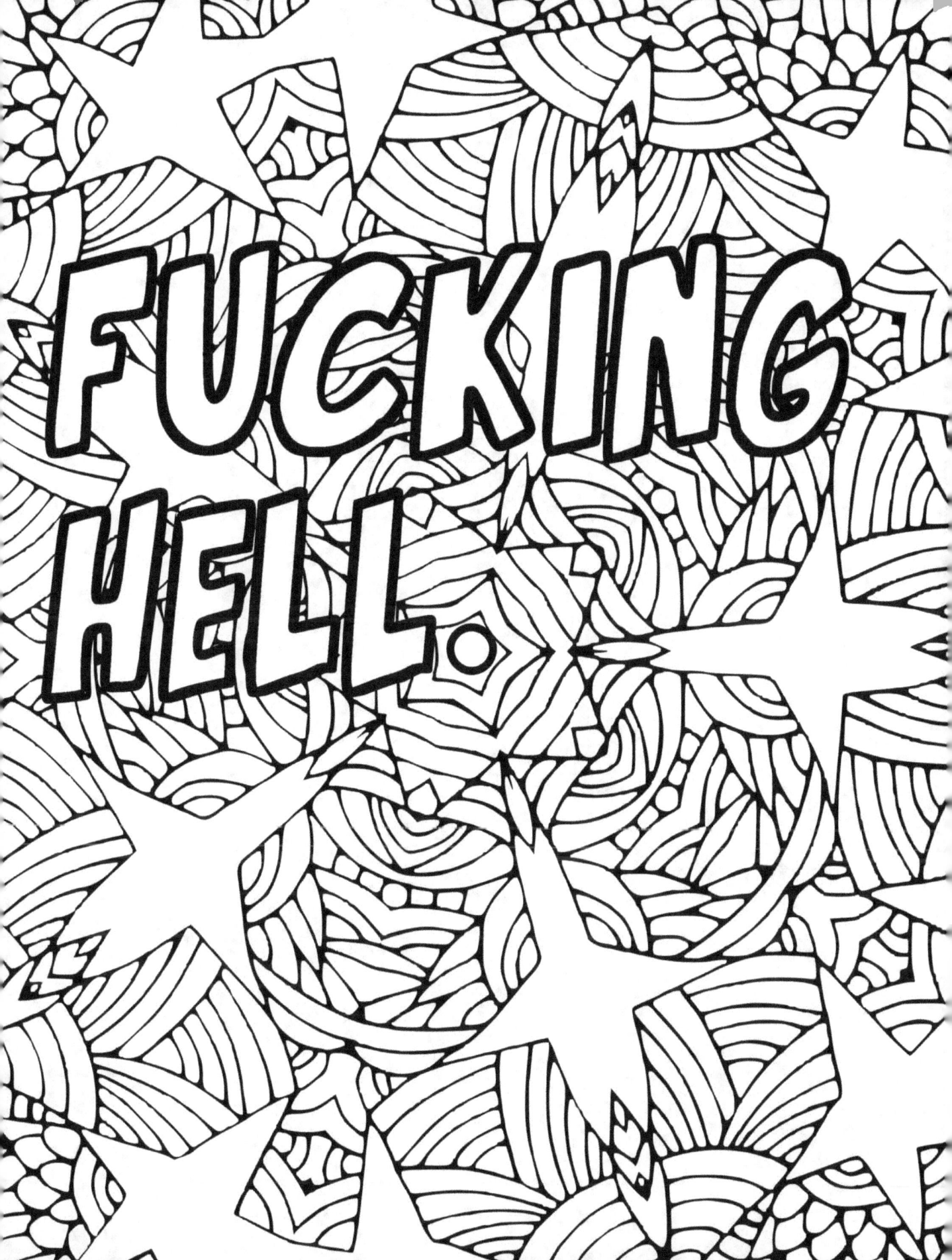

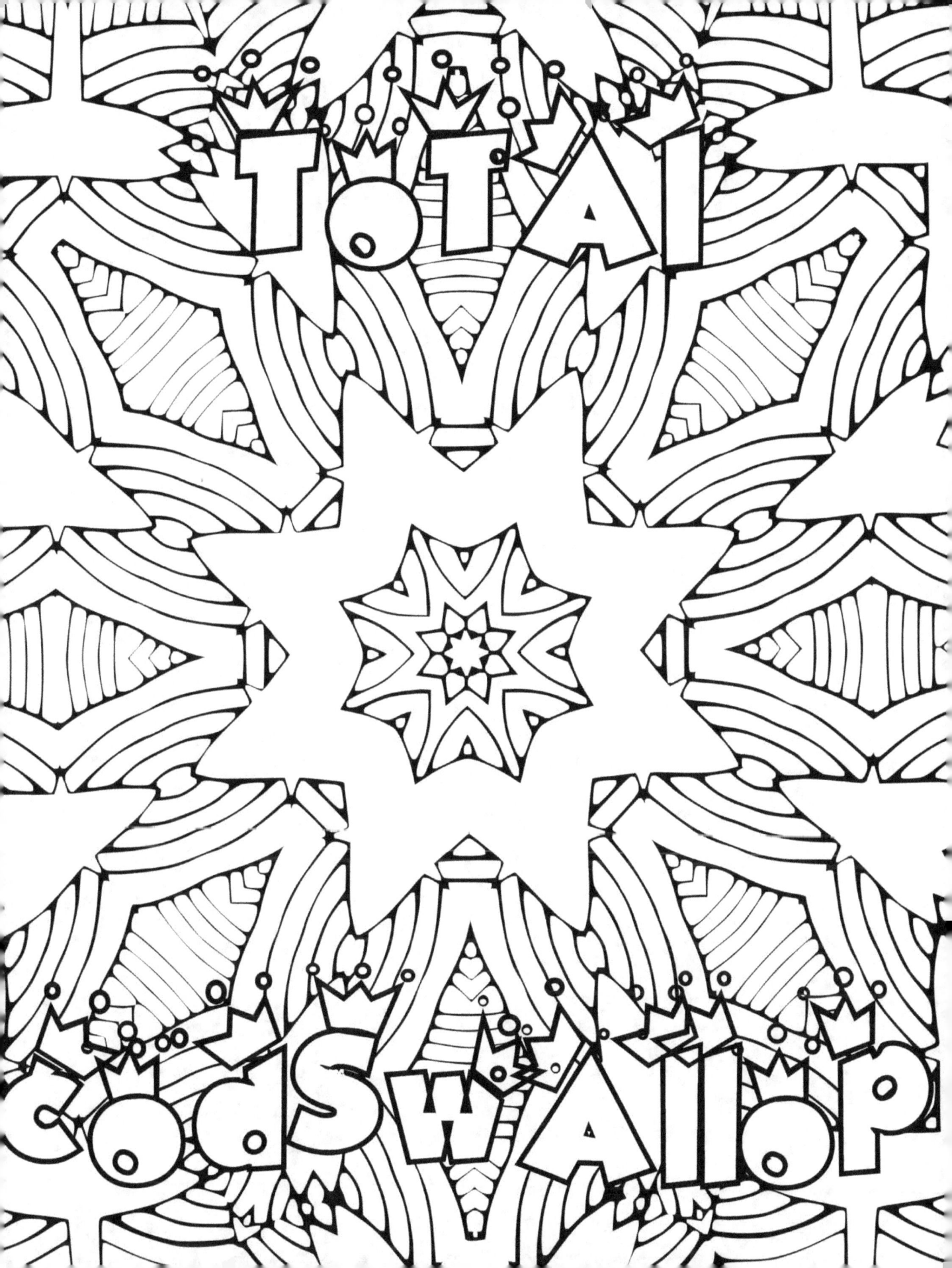

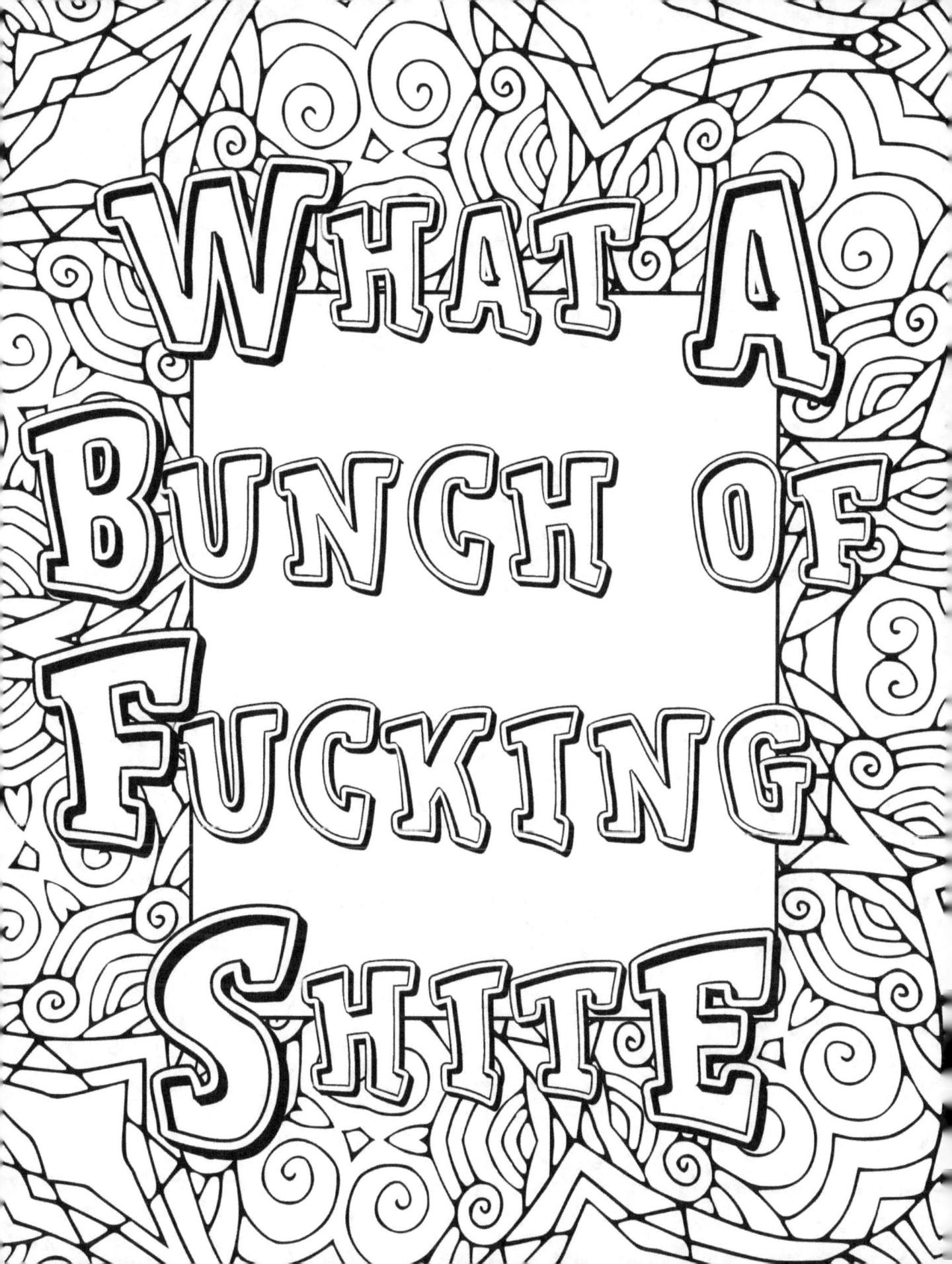

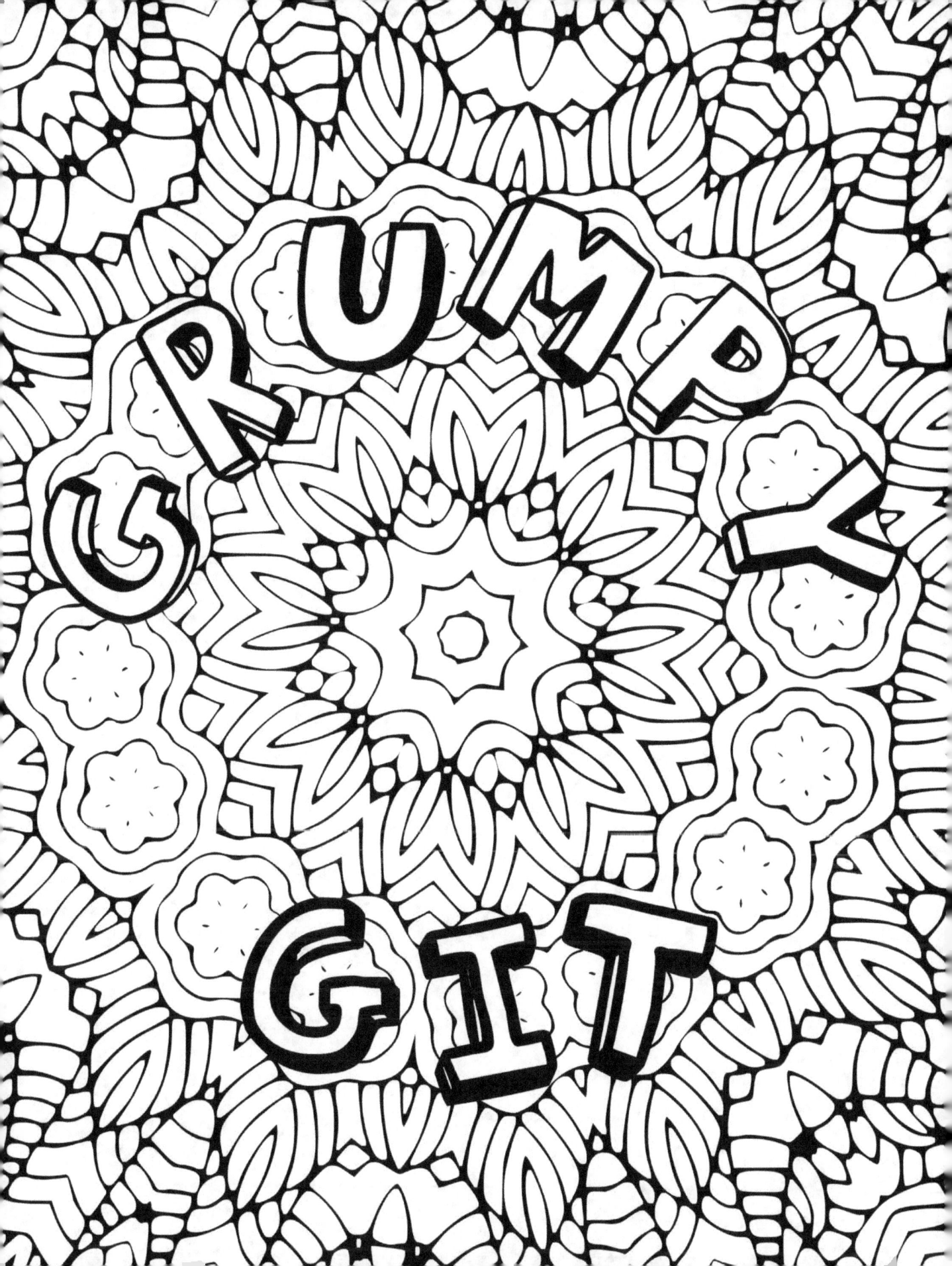

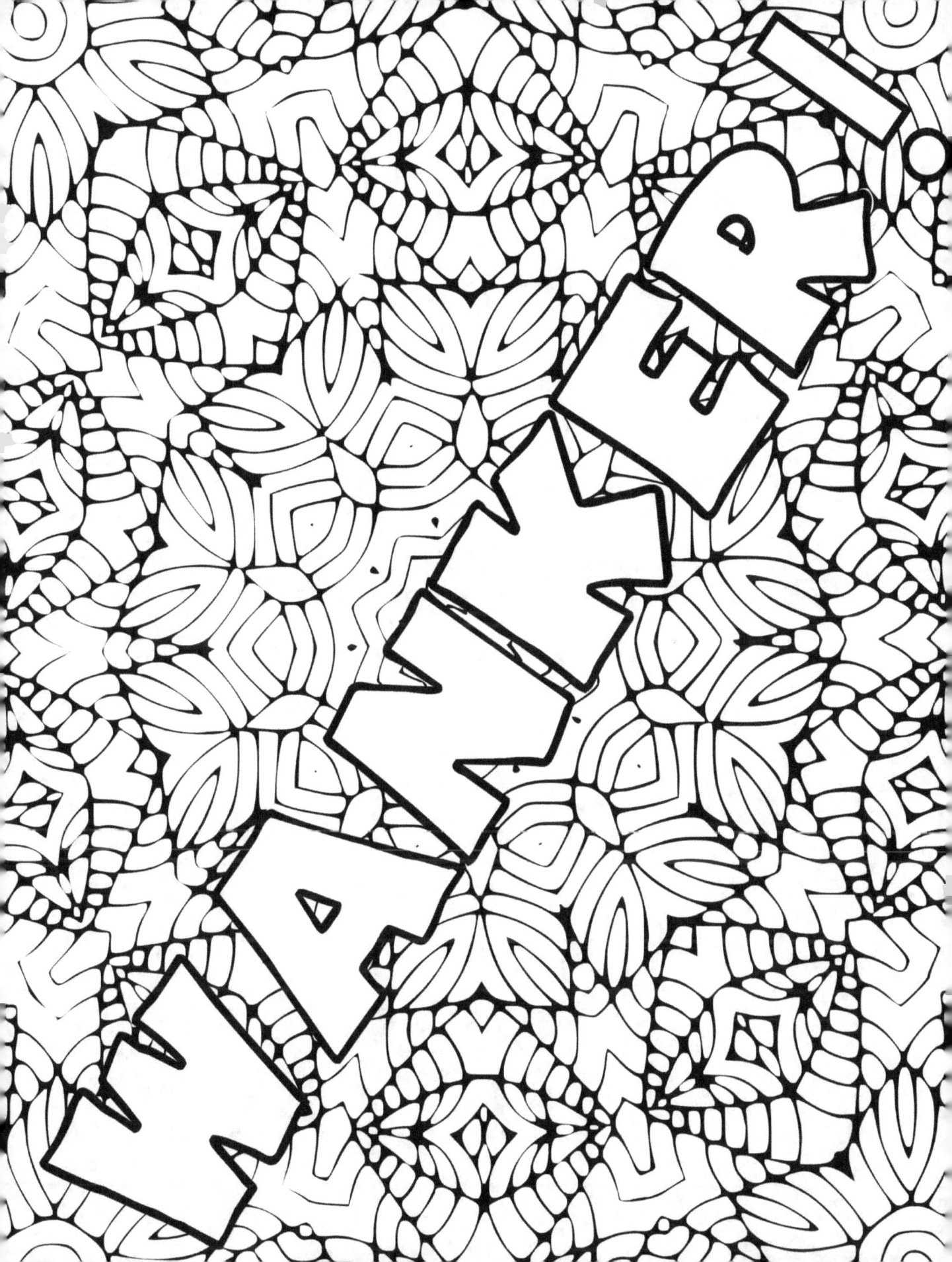

www.ingramcontent.com/pod-product-compliance
Lightning Source LLC
Chambersburg PA
CBHW081644220526
45468CB00009B/2549